D0210619

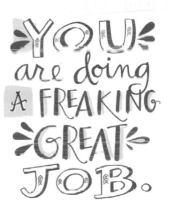

YOU
are doing
A FREAKING
GREAT
JOB.

Library of Congress Cataloging-in-Publication Data is available.

ISBN 978-0-7611-8447-8

Special discounts on Bulk Orders
YOU ARE DOING A FREAKING GREAT JOB is available at special discounts
when purchased in bulk for use as a corporate gift, premium,
sales promotion, or fundraiser. Special editions or book excerpts can
also be created to specification. For more information, please email
specialsales@workman.com or call us at (212) 614-7509.

Design by Kat Millerick

Cover Illustration © Emily McDowell

Workman Publishing Co., Inc.
225 Varick Street
New York, NY 10014-4381
workman.com

WORKMAN is a registered trademark of Workman Publishing Co., Inc.

Printed in China
First printing March 2015

10 9 8 7 6 5 4

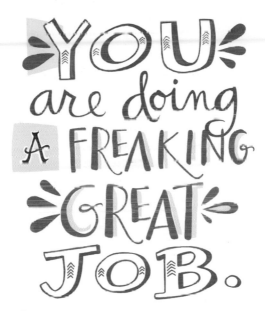

YOU are doing A FREAKING GREAT JOB.

and OTHER REMINDERS OF YOUR AWESOMENESS

Workman Publishing • New York

AN^INTRODUCTION

encouraging little

Keep your head up.

Take your time.

Be proud of yourself.

Always remember: You are right

where you're supposed to be.

| YOU ARE DOING A FREAKING GREAT JOB.

YOU DESERVE ALL THE GOOD THINGS

| YOU ARE DOING A FREAKING GREAT JOB.

HERE comes THE Sun...

The Beatles

MAKE LIKE A SUPERHERO

Before your next big meeting or job interview, stand with
your feet shoulder-width apart and put your hands on
your hips. A 2012 study by the Harvard Business School
found that striking a high-power pose like this increases
testosterone and lowers stress, leading to
better performance.

Nothing is impossible,
the word itself says
"I'm possible"!

-Audrey Hepburn

| YOU ARE DOING A FREAKING GREAT JOB.

BACK TO BASICS

| YOU ARE DOING A FREAKING GREAT JOB.

DAYDREAMING is a MANDATORY DAILY EXERCISE

YOU ARE
ENOUGH

| YOU ARE DOING A FREAKING GREAT JOB.

Always be a First-rate version of yourself instead of a second-rate version of somebody else.

Judy Garland

| YOU ARE DOING A FREAKING GREAT JOB.

MAKE *yourself* PROUD

— PETER W. SMITH

Be Curious, Not Judgmental
-Walt Whitman

IF AT FIRST YOU DON'T SUCCEED . . .

Some of the world's most accomplished people experienced overwhelming failure before finding incredible success:

Thomas Edison had about 1,000 failed attempts before inventing the lightbulb.

Dr. Seuss's first book was rejected by 27 publishers.

Lucille Ball was known as the "Queen of B Movies" before landing her timeless sitcom.

James Dyson created 5,126 failed prototypes for his bagless vacuum.

Michael Jordan was cut from his high school basketball team.

YOU ARE DOING A FREAKING GREAT JOB.

FiRST

FAiLURE

THEN

SUCCESS

| YOU ARE DOING A FREAKING GREAT JOB.

ALL FIND
WHAT THEY
TRULY
SEEK

| YOU ARE DOING A FREAKING GREAT JOB.

SURRENDER YOURSELF TO PEACE OF MIND

THE AWW-INDUCING PRODUCTIVITY TIP

A study found that looking at cute images of cuddly
puppies and sweet babies can increase attention
to detail and result in better quality of work.
Bring on the itty-bitties!

TO
BEGIN,

begin.

| YOU ARE DOING A FREAKING GREAT JOB.

REBOOT PLAYLIST

"Get Up Offa That Thing," James Brown

"Are You Ready for This," Jock Jams

"Hey Ya!," Outkast

"Wanna Be Startin' Somethin'," Michael Jackson

"One More Time," Daft Punk

"Ain't No Mountain High Enough," Marvin Gaye and Tammi Terrell

"Steal My Sunshine," Len

"Can I Kick It?," A Tribe Called Quest

"Praise You," Fatboy Slim

| YOU ARE DOING A FREAKING GREAT JOB.

Each morning we are born again.

Buddha

| YOU ARE DOING A FREAKING GREAT JOB.

TURN YOUR

NAYS

INTO

YAYS

MAKE YOUR OWN MANTRA

Create some personal mantras to improve your mood and outlook. Choose three things you'd like to change about yourself or your situation and incorporate each into a sentence that begins "I am." (For example, "I am stressed.") Then write each phrase's opposite ("I am stressed" might become "I am relaxed"). Write these three positive statements on a card, decorate it any way you like, and set it in a place you see often. Repeat your three uplifting mantras regularly throughout the day and prepare to feel good.

| YOU ARE DOING A FREAKING GREAT JOB.

EXPLORE THE WORLD AROUND YOU

| YOU ARE DOING A FREAKING GREAT JOB.

what you SEE depends on what you're LOOKING for.

8 VEGGIES AND HERBS YOU CAN
GROW FROM KITCHEN SCRAPS

Garlic

Scallions

Romaine lettuce

Basil

Cilantro

Bok choy

Ginger

Avocado

Let Us
CULTIVATE
Our
GARDEN
— Voltaire

YOU ARE DOING A FREAKING GREAT JOB.

WHY set YOUR
Sights on A Star
of KNOWN BRIGHTNESS
when YOU can create
a STAR of YOUR
OWN BRIGHTNESS ✫

| YOU ARE DOING A FREAKING GREAT JOB.

always be on the LOOKOUT for THE PRESENCE OF Wonder.

-E. B. WHITE

TOMORROW'S

Another

DAY

CHOCOLATE ESPRESSO MUG CAKE

Nonstick cooking spray
3 tablespoons all-purpose flour
1 teaspoon instant coffee powder
2 tablespoons sweetened cocoa powder
3 tablespoons sugar
¼ teaspoon baking powder
2 tablespoons milk
1 large egg
2 tablespoons vegetable oil
½ teaspoon pure vanilla extract
Vanilla ice cream or confectioners' sugar, for serving

1. Mist the inside of a coffee mug with nonstick cooking spray.
2. Combine the dry ingredients in a large mixing bowl. Add the wet ingredients and stir together with a fork until just combined.
3. Pour the batter into the mug and microwave on high until cooked through, 90 seconds.
4. Serve with a scoop of vanilla ice cream or dust with confectioners' sugar.

Makes 1 cake

YOU ARE DOING A FREAKING GREAT JOB.

| YOU ARE DOING A FREAKING GREAT JOB.

| YOU ARE DOING A FREAKING GREAT JOB.

BEST BIKE TRAILS FOR CITY DWELLERS

Midtown Greenway: Minneapolis, Minnesota

Burke-Gilman Trail: Seattle, Washington

Green Cycle Routes: Copenhagen, Denmark

Eastbank Esplanade: Portland, Oregon

Minuteman Commuter Bikeway: Boston, Massachusetts

Lakefront Trail: Chicago, Illinois

The Canal St. Martin: Paris, France

Manhattan Waterfront Greenway: New York, New York

American River Bike Trail: Sacramento, California

Schuylkill River Trail: Philadelphia, Pennsylvania

| YOU ARE DOING A FREAKING GREAT JOB.

| YOU ARE DOING A FREAKING GREAT JOB.

| YOU ARE DOING A FREAKING GREAT JOB.

YOU CAN DO

ANYTHING

BUT NOT

everything

DAVID ALLEN

GRIN AND BEAR IT

Scientific studies show that smiling
relieves stress and improves
heart health. The act of smiling is
contagious, too; the brain is hardwired
for sociability, and our natural
response is to mirror the expression.

| YOU ARE DOING A FREAKING GREAT JOB.

CLEAR YOUR CHAKRAS

The seven chakras are known as points of energy in the "subtle" body rather than the physical. When the chakras are open and clear, energy flows easily through these channels to create an overall sense of well-being.

The Solar Plexus Chakra, associated with self-worth, self-esteem, and confidence, is located in the upper abdomen and often referred to as the Manipura. When this chakra is balanced, you will feel friendly, capable, and at peace with yourself. It allows you to take risks and instills a curiosity about the world around you. When closed, the Manipura can cause confusion and a decrease in self-esteem, which manifest as digestive, liver, and breathing problems. To strengthen this chakra, spend time outdoors appreciating the natural world, and pick up long-forgotten hobbies that you've always enjoyed.

KEEP YOUR HEAD UP.

KEEP YOUR HEART STRONG.
—BEN HOWARD

| YOU ARE DOING A FREAKING GREAT JOB.

FIREFLIES IN A JAR

For a colorful glow-in-the-dark lantern, cut
open a glow stick and pour the contents into
a jar. Add a capful of your favorite glitter,
seal the top with a lid, and shake.

EVERY HOUR
of THE LIGHT &
DARK IS A
MIRACLE

— Walt Whitman

SPREAD GOOD VIBES

In 2007, a group of teens attending a leadership camp at Harding University devised a plan to institute a National Day of Encouragement. Their goal? "Inspiring Americans to make deliberate words and acts of encouragement a part of . . . every day of their lives." Today seems like the perfect day to get started.

| YOU ARE DOING A FREAKING GREAT JOB.

Dream

BIG

| YOU ARE DOING A FREAKING GREAT JOB.

A ship is safe
in harbor,
but that's not
what ships
are for.

William Shedd

YOU ARE DOING A FREAKING GREAT JOB.

DON'T FIGHT THE PROBLEM

decide it.

GEORGE C. MARSHALL

| YOU ARE DOING A FREAKING GREAT JOB.

buy the ticket

Take the Ride

HUNTER S. THOMPSON

EASY PESTO

2 cups basil leaves
4 good-size garlic cloves, chopped
1 cup walnut halves
1 cup olive oil
1 cup freshly grated Parmesan cheese
¼ cup freshly grated Romano cheese
Salt and black pepper, to taste

Combine the basil, garlic, and walnuts in the bowl of a food
processor and pulse to chop. Leave the motor running and add
the olive oil in a slow, steady stream. Shut the motor off, and
add the cheeses and a big pinch of salt and pepper. Process
briefly to combine.

Makes about 2 cups

| YOU ARE DOING A FREAKING GREAT JOB.

SIMPLE

IS

GOOD

-JIM HENSON-

| YOU ARE DOING A FREAKING GREAT JOB.

Reach high, for STARS lie hidden in your SOUL. Dream deep, for EVERY dream precedes the GOAL.

—Pamela Vaull Starr

DIY SHARPIE MUG

Customize a plain mug with a beautiful design or a funny message for a morning motivation boost.

1. Preheat the oven to 350°F.

2. Use an oil-based Sharpie or glass paint (water-based Sharpies won't work!) to draw on the mug. Let dry.

3. Bake the mug to set the paint, 20 minutes.

Note: The ink may come off in the dishwasher, so wash the mug by hand instead.

| YOU ARE DOING A FREAKING GREAT JOB.

| YOU ARE DOING A FREAKING GREAT JOB.

SIZE DOESN'T MATTER

Leafcutter ants can carry an object 50
times their own body weight in their jaws.
To put that in perspective, think of a human
using her teeth to lift a truck.

YOU ARE

CAPABLE

of

MORE

THAN YOU KNOW

OZ

THE GREAT & POWERFUL

| YOU ARE DOING A FREAKING GREAT JOB.

DREAMS & ACTION MUST BE *woven* TOGETHER

YOU ARE WHAT YOU WEAR

Adding color to your wardrobe can give you a boost
of self-confidence. Wearing certain colors can also
have an impact on your mood; a little purple or
orange is great for a shot of energy.

| YOU ARE DOING A FREAKING GREAT JOB.

NO ONE
LOOKS
stupid
WHEN THEY'RE
HAVING
FUN

AMY POEHLER

| YOU ARE DOING A FREAKING GREAT JOB.

Let's RUN AWAY to Dance AND Play

TED TALKS THAT MOTIVATE AND INSPIRE

"The Puzzle of Motivation"
by Dan Pink

"How Great Leaders Inspire Action"
by Simon Sinek

"Why We Do What We Do"
by Tony Robbins

"Your Elusive Creative Genius"
by Elizabeth Gilbert

"The Happy Secret to Better Work"
by Shawn Achor

"Brain Magic"
by Keith Barry

YOU ARE DOING A FREAKING GREAT JOB.

always
believe
something
wonderful
is about to
happen

| YOU ARE DOING A FREAKING GREAT JOB.

Make Each Day
your
MASTERPIECE

−JOHN WOODEN

| YOU ARE DOING A FREAKING GREAT JOB.

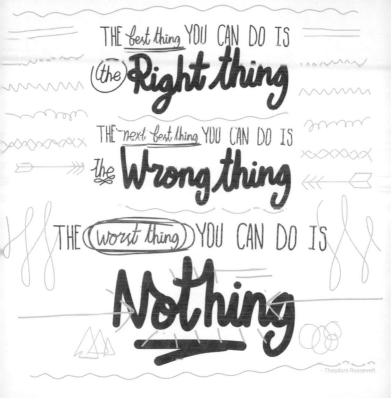

THE *best thing* YOU CAN DO IS

(the) **Right thing**

THE *next best thing* YOU CAN DO IS

the **Wrong thing**

THE (*worst thing*) YOU CAN DO IS

Nothing

- Theodore Roosevelt

THE LOVELY LANGUAGE OF FLOWERS

Express any sentiment with the gift of a flower:

Black-Eyed Susan = encouragement

Casablanca Lily = celebration

Geranium = comfort

Hydrangea = perseverance

Pansy = loving thoughts

Pink Carnation = gratitude

Pink Rose = friendship

Poppy = consolation

Statice = success

Sunflower = adoration

White Tulip = forgiveness

OVERCOME FEAR WITH
THE *AWARE* TECHNIQUE

A: Acknowledge your fear.

W: Watch the anxiety—imagine it's outside of you and you're just observing it.

A: Act normally, telling your unconscious mind to relax.

R: Repeat these steps until you start to relax again.

E: Expect the best.

FIND WHAT YOU'RE

Afraid of most

AND GO LiVE There.

x

Chuck Palahniuk

| YOU ARE DOING A FREAKING GREAT JOB.

SO GIVE ME

hope

IN THE

DARKNESS

THAT I WILL *See* THE

light

= MUMFORD + SONS =

| YOU ARE DOING A FREAKING GREAT JOB.

Blossom by Blossom

THE SPRING BEGINS

A.C. SWINBURNE

| YOU ARE DOING A FREAKING GREAT JOB.

GO.
yield.
SURRENDER
to the magical
wilderness of your mind.
the SPLENDor of REVERIE.
the LAWLESSNESS of
Imagination
where ANYTHING is
possible.

LIQUID COURAGE

If the occasion calls for fortitude, you may find it fastest in a bottle. Some shot-and-chaser combos, just in case:

Dark rum + ginger beer

Bourbon + sweet tea

Tequila + salted lime

Vodka + sugared lemon slice

Irish whiskey + beer

Single malt scotch + a microbrew

THE ONLY **COURAGE** THAT MATTERS IS THE KIND THAT GETS YOU FROM **ONE MOMENT TO THE NEXT.**

MIGNON McLAUGHLIN

Coming Up

| YOU ARE DOING A FREAKING GREAT JOB.

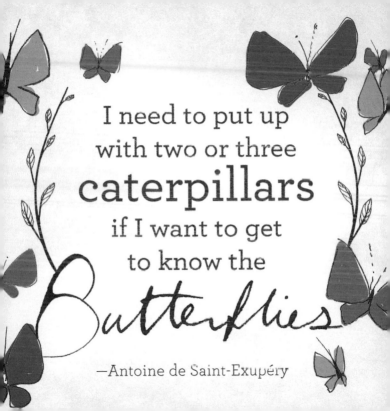

I need to put up
with two or three
caterpillars
if I want to get
to know the
Butterflies

—Antoine de Saint-Exupéry

128 YOU ARE DOING A FREAKING GREAT JOB.

| YOU ARE DOING A FREAKING GREAT JOB.

| YOU ARE DOING A FREAKING GREAT JOB.

BEING NICE makes YOU COOL

MOST INSPIRING COMMENCEMENT SPEECHES
(THAT YOU CAN READ OR WATCH ONLINE)

Carrie Chapman Catt at Sweet Briar College, 1936

John F. Kennedy at American University, 1963

Gwendolyn Brooks at University of Vermont, 1986

Cornel West at Wesleyan University, 1993

David Foster Wallace at Kenyon College, 2005

Steve Jobs at Stanford University, 2005

Stephen Colbert at Knox College, 2006

Bill Cosby at Temple University, 2007

Ellen DeGeneres at Tulane University, 2009

Angela Davis at Pitzer College, 2012

Shonda Rhimes at Dartmouth University, 2014

YOU ARE DOING A FREAKING GREAT JOB.

| YOU ARE DOING A FREAKING GREAT JOB.

NOT till
we are →
LOST
DO WE BEGIN
to find
OURSELVES

HENRY DAVID THOREAU

| YOU ARE DOING A FREAKING GREAT JOB.

the

UNIVERSE

is full of

MAGICAL THINGS.

PATIENTLY WAITING FOR

our wits

to GROW SHARPER.

(EDEN PHILLPOTTS AUTHOR 1862-1960)

| YOU ARE DOING A FREAKING GREAT JOB.

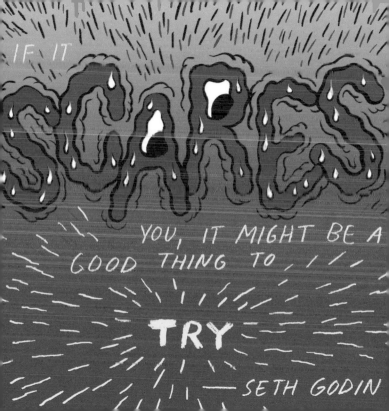

| YOU ARE DOING A FREAKING GREAT JOB.

Little

BY

Little

| YOU ARE DOING A FREAKING GREAT JOB.

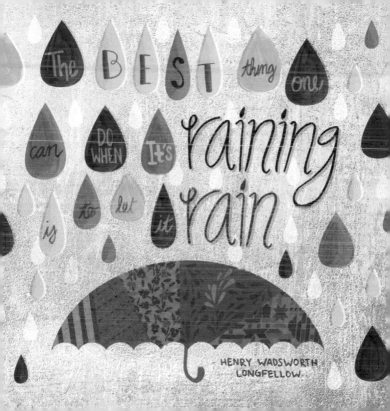

The BEST thing one can DO WHEN It's raining rain is to let it rain

— HENRY WADSWORTH LONGFELLOW

THE POWER OF MENTORSHIP

Many of the most successful people credit a mentor as the root of their achievements. Whether the mentor is in your field or not, she takes you under her wing and becomes an invaluable resource and guide throughout your career. Sometimes this relationship happens organically; other times, you will have to seek someone out. When choosing a mentor, look for someone who has the time to teach you, who is understanding of the pressures you face outside of work, and who raises the bar for you while inspiring you to make your own choices.

IT'S NEVER TOO LATE TO BEGIN

Nelson Mandela became president at age 75.

Katharine Hepburn won an Oscar at 74.

John Glenn was 77 when he flew his last space mission.

Julia Child learned to cook when she was 38.

Leonardo da Vinci got his big break at 46.

YOUTH
– HAS NO –
AGE
– pablo picasso –

| YOU ARE DOING A FREAKING GREAT JOB.

· BE A ·

Warrior

NOT A WORRIER

| YOU ARE DOING A FREAKING GREAT JOB.

don't let PERFECT BE THE ENEMY OF GOOD

-VOLTAIRE-

FUN SOLO ACTIVITIES

- Try a new exercise class

- Bring a sketchbook to the park

- Check out the new exhibit at your favorite museum

- Shop for something frivolous

- Volunteer at an animal shelter

- Pamper yourself with a day at the spa

- Catch a matinee movie (extra points for playing hooky)

Make
the most
of yourself,
for that is all
there is of
You

| YOU ARE DOING A FREAKING GREAT JOB.

GROW

SOMETHING.

| YOU ARE DOING A FREAKING GREAT JOB.

Everyone Looks Good In A

SMILE

| YOU ARE DOING A FREAKING GREAT JOB.

LET iT BE

LET iT BE

LET iT BE

— THE BEATLES

YOU ARE DOING A FREAKING GREAT JOB.

SUCCESS

IS GETTING

WHAT YOU WANT

HAPPINESS

IS WANTING

WHAT YOU GET.

W. P. Kinsella

| YOU ARE DOING A FREAKING GREAT JOB.

FOLLOW YOUR PASSION

BADASS WOMEN THROUGHOUT HISTORY

KHUTULUN: Thirteenth-century Mongolian warrior princess who chose her husband based on a wrestling match (if he could beat her, she would marry him)

POLICARPA SALAVARRIETA: Colombian revolutionary who posed as a seamstress while spying on Royalist families to free Colombia from Spain's rule

CHING SHIH: Chinese pirate who ruled the Red Flag Fleet, one of Asia's biggest pirate crews, during its height of power— even the Chinese government couldn't defeat her ship

GERTRUDE BELL: British scholar and mountaineer who traveled the world twice before establishing the borders of modern-day Iraq and helping to appoint the country's first government officials

THE NIGHT WITCHES: Russian WWII fighter pilots who were the first women to carry out active military orders

HEDY LAMARR: Austrian inventor and actress who laid the groundwork for communication through wireless technology

| YOU ARE DOING A FREAKING GREAT JOB.

It matters not what someone is born, but what they grow to be.

Albus Dumbledore

THE LONGEST BOOKS ABSOLUTELY WORTH READING

Gone with the Wind by Margaret Mitchell ≈ 1,030 pages

Don Quixote by Miguel de Cervantes ≈ 990 pages

Infinite Jest by David Foster Wallace ≈ 1,100 pages

War and Peace by Leo Tolstoy ≈ 1,295 pages

The Stand by Stephen King ≈ 1,200 pages

Lonesome Dove by Larry McMurtry ≈ 840 pages

U.S.A. by John Dos Passos ≈ 1,300 pages

2666 by Roberto Bolaño ≈ 1,100 pages

it always SEEMS IMPOSSIBLE until it's DONE

NELSON MANDELA

| YOU ARE DOING A FREAKING GREAT JOB.

With a
new day
Comes new
Strengths
and
new
thoughts

- Eleanor Roosevelt

WHAT
→·ARE YOU·←
WAITING
⊱·FOR·⊰

| YOU ARE DOING A FREAKING GREAT JOB.

"OH, THE PLACES YOU'LL GO!"

—Dr. Seuss

HOMEMADE FORTUNE COOKIES

Nonstick cooking spray
3 egg whites
¾ cup sugar
½ cup (1 stick) butter, melted
¼ teaspoon pure vanilla extract
¼ teaspoon almond extract
1 cup all-purpose flour

1. Preheat the oven to 375°F. Mist a baking sheet with cooking spray and write fortunes on small strips of paper.

2. Place the egg whites and sugar in a large bowl and whip with an electric mixer until frothy. Stir in 2 tablespoons of water and the remaining ingredients until combined.

3. Spoon the batter onto the baking sheet to form 3-inch circles spaced evenly apart. Bake until the edges are browned slightly, 5 to 7 minutes.

4. While the cookies are still warm, place a message in the center of each. Fold each cookie in half to conceal the message, then bring the corners together to form a horseshoe shape. Let cool.

Makes 36 cookies

YOU ARE DOING A FREAKING GREAT JOB.

many SURPRiSES await YOU

- Two Door Cinema Club

| YOU ARE DOING A FREAKING GREAT JOB.

TO PLANT A *garden* IS TO BELIEVE IN *tomorrow*

AUDREY HEPBURN

| YOU ARE DOING A FREAKING GREAT JOB.

the best way out is always through.

HELEN KELLER

AN OUTSTANDING FEAT

Despite a wingspan of only four inches, North American monarch butterflies travel up to 3,000 miles each year to reach warmer winter climates in Mexico and California. Some even return to the same trees their ancestors visited before them.

reach for the STARS

| YOU ARE DOING A FREAKING GREAT JOB.

Dont Be Pushed by your Problems, be led by your Dreams

Ralph Waldo Emerson

| YOU ARE DOING A FREAKING GREAT JOB.

LET YOUR *heart* BE YOUR *guide.*

YOU ARE DOING A FREAKING GREAT JOB.

REPLACE
FEAR
of the
UNKNOWN
with
CURIOSITY

—DANNY GOKEY

MAKE EVERY DAY A CELEBRATION

Fill up the week with extraordinary things. Call someone who makes you laugh, especially when you don't feel like talking to anyone. Eat a little extra. Look at yourself in the mirror and say something nice. Dress fancy for work. Smile at the barista. Keep your face open. Play your favorite song as soon as you wake up. Dance a little harder. Sing a little louder. Sad songs are okay, too. Read an article or poem that puts a smile on your face. Light a candle. Breathe in the smell of clean sheets. Wake up and reach for the ceiling instead of your phone. Clean—your house, your desk, your friend list, your mind. Most of all, celebrate *you* every single day.

PARTY TIME!

EXCELLENT!

WAYNE'S WORLD

IN THE

MIDDLE

OF

DIFFICULTY

LIES

OPPORTUNITY

| YOU ARE DOING A FREAKING GREAT JOB.

SPREAD *your* ARMS
&
TRUST *your* CAPE

A THUMBS-UP TIMELINE

SIX MILLION YEARS AGO: Hominids develop thumbs

ANCIENT ROME: Spectators decide the fates of
fighting gladiators by giving a thumbs-up
or thumbs-down

THE MIDDLE AGES: Merchants seal business transactions
with a thumbs-up

WORLD WAR II: American soldiers spread the gesture
throughout Europe as a means of communication

TWENTY-FIRST CENTURY: Thumbs turn horizontal for
texting purposes

| YOU ARE DOING A FREAKING GREAT JOB.

Thumbs UP!

| YOU ARE DOING A FREAKING GREAT JOB.

SOMETHING FABULOUS is out there TAKING SHAPE emerging · peeking CALLING YOUR name

| YOU ARE DOING A FREAKING GREAT JOB.

PERHAPS THE GREATEST ILLUSION IS THAT LIFE COULD GET ANY MORE WONDERFUL THAN IT ALREADY IS

| YOU ARE DOING A FREAKING GREAT JOB.

| YOU ARE DOING A FREAKING GREAT JOB.

THE IMPORTANT THING IS TO SOMEHOW

BEGIN.

– HENRY MOORE

| YOU ARE DOING A FREAKING GREAT JOB.

Believe you can
you're halfway
there

—THEODORE ROOSEVELT

A DAB OF THIS

Headaches, mood swings, pimples, anxiety—most common ailments can be ameliorated by a touch of essential oil. To restore emotional and physical balance, try one of these (follow the instructions on the package):

Lavender oil = eliminates stress

Tea tree oil = zaps breakouts

Jasmine oil = works as a natural antidepressant

Peppermint oil = reduces fatigue

Eucalyptus oil = acts as a decongestant

Almond oil = moisturizes

Patchouli oil = combats aging

Life is LIKE RIDING a BICYCLE. To keep YOUR BALANCE YOU MUST keep MOVING.

ALBERT EINSTEIN

BOOKS TO FEED WANDERLUST

On the Road by Jack Kerouac

Zen and the Art of Motorcycle Maintenance
by Robert M. Pirsig

The Baron in the Trees by Italo Calvino

A Motor-Flight Through France by Edith Wharton

Tracks by Robyn Davidson

Fear and Loathing in Las Vegas by Hunter S. Thompson

Home by Toni Morrison

Lucy by Jamaica Kincaid

Angels by Denis Johnson

Adventures of Huckleberry Finn by Mark Twain

Wild by Cheryl Strayed

| YOU ARE DOING A FREAKING GREAT JOB.

LIVE, TRAVEL, ADVENTURE, BLESS & DON'T BE SORRY —JACK KEROUAC

| YOU ARE DOING A FREAKING GREAT JOB.

THIS LITTLE
LIGHT
OF MINE
I'm GONNA let it
SHINE

— HARRY DIXON LOES —

YOU ARE DOING A FREAKING GREAT JOB.

SAY YES! & YOU'LL FIGURE IT OUT AFTER → TINA FEY

HOW TO SAY "AWESOME!" IN 10 DIFFERENT LANGUAGES

ALBANIAN: *i tmerrshëm!*

CZECH: *děsivý!*

DUTCH: *ontzagwekkend!*

FINNISH: *mahtava!*

FRENCH: *impressionnant!*

GERMAN: *ehrfürchtig!*

HUNGARIAN: *döbbenetes!*

INDONESIAN: *mengagumkan!*

ITALIAN: *imponente!*

SPANISH: *¡impresionante!*

| YOU ARE DOING A FREAKING GREAT JOB.

WiCKeD

AWESOME

| YOU ARE DOING A FREAKING GREAT JOB.

| YOU ARE DOING A FREAKING GREAT JOB.

GRAPEFRUIT AND STRAWBERRY GREYHOUND ICE POP

1 cup freshly squeezed grapefruit juice
12 ounces (about ¾ pint) whole strawberries, hulled
5 ounces vodka

1. Puree the grapefruit juice and strawberries in a blender. Add the vodka and blend until combined.

2. Divide the mixture between 18 ice pop molds.

3. Cover the ice pop form with aluminum foil. Cut small holes in the foil, centering them over each well. Insert an ice pop stick through each hole. Freeze until the pops are solid, at least 6 hours.

Makes 18 ice pops

| YOU ARE DOING A FREAKING GREAT JOB.

| YOU ARE DOING A FREAKING GREAT JOB.

THE TIME FOR
ACTION IS

NOW

YOU ARE DOING A FREAKING GREAT JOB.

With freedom, books, flowers & the moon, who could not be happy?

oscar Wilde

| YOU ARE DOING A FREAKING GREAT JOB.

WHEN NOTHING IS SURE *everything* IS POSSIBLE

MARGARET DRABBLE

BLAZE NEW TRAILS

Sometimes even the slightest shift in perspective can radically alter your view on life. Lawrence C. Katz, Ph.D., and Manning Rubin, authors of *Keep Your Brain Alive*, recommend changing up your daily commute to keep the brain stimulated. "An unfamiliar route activates the cortex and hippocampus to integrate the novel sights, smells, and sounds you encounter into a new brain map," they say. So grab a coffee, chart a new course, and get ready to see things differently.

TAKE the SCENIC ROUTE

| YOU ARE DOING A FREAKING GREAT JOB.

Every single day do something that makes your heart sing.

~Marcia Wieder

| YOU ARE DOING A FREAKING GREAT JOB.

Make
good
art.

DANCE PARTY PLAYLIST

"Like a Prayer," Madonna

"Paradise by the Dashboard Light," Meatloaf

"Crazy," Gnarls Barkley

"Kiss," Prince

"Ignition (Remix)," R. Kelly

"I Wanna Dance with Somebody (Who Loves Me)," Whitney Houston

"Super Freak," Rick James

"Poison," Bell Biv DeVoe

"All Night Long," Lionel Richie

"Call Me Maybe," Carly Rae Jepsen

IN
THICKEST DARKNESS

THE STARS SHINE

BRIGHTEST

Henry David Thoreau

MINDFUL EMAIL

There is beauty in the idea that we alone control how we present ourselves to the world. When expressing yourself through technology, try this mindful meditation tip to get your message across the right way:

"Sit for a few minutes feeling your breath. Then reflect that one or more human beings, all of whom wish to be happy, just as you do, will be receiving an email you've written. Recognize that emotional tone is hard to convey in an email, and if it is unclear what emotional context you intend in your message, you may be misunderstood. Compose your email. Put yourself in the recipients' shoes as you reread the email. Revise it if necessary. Take three breaths before you decide whether it is time or not to press Send."
—Sharon Salzberg, *Real Happiness at Work*

YOU ARE DOING A FREAKING GREAT JOB.

When you're in the DOLDRUMS, KEEP LOOKING for the wind.

| YOU ARE DOING A FREAKING GREAT JOB.

BE
TRUTHFUL
gentle
AND
FEARLESS
GANDHI

| YOU ARE DOING A FREAKING GREAT JOB.

| YOU ARE DOING A FREAKING GREAT JOB.

Creativity takes Courage

| YOU ARE DOING A FREAKING GREAT JOB.

| YOU ARE DOING A FREAKING GREAT JOB.

Be Your Own Happy Place

PARTNERS FOR LIFE

They say the best things in life are always shared. These tight-knit animal teams accomplish much more together than on their own—the ultimate definition of a win-win.

zebra + ostrich

caterpillar + ant

clownfish + sea anemone

honeyguide bird + honey badger

egret + hippo

human + dog

you don't get

•HARMONY•

when Everybody

SINGS THE SAME

note.

- Doug Floyd

A COSMIC CALENDAR

If the entire 13.8-billion-year history of the universe was condensed into a twelve-month calendar—with the Big Bang occurring on January 1—human life would occupy roughly the last minute of December 31.

| YOU ARE DOING A FREAKING GREAT JOB.

Life is just a moment **SO ENJOY IT**

ROY AYERS

| YOU ARE DOING A FREAKING GREAT JOB.

taking *less* THE ROAD TRAVELED

| YOU ARE DOING A FREAKING GREAT JOB.

| YOU ARE DOING A FREAKING GREAT JOB.

YOU WERE MADE TO BE AWESOME

KID PRESIDENT

| YOU ARE DOING A FREAKING GREAT JOB.

| YOU ARE DOING A FREAKING GREAT JOB.

| YOU ARE DOING A FREAKING GREAT JOB.

don't count
THE DAYS
MAKE THE DAYS
COUNT

MUHAMMAD ALI

SOMETIMES GRILLED CHEESE IS THE ANSWER

Grilled cheese is the king of simple sandwiches, and it doesn't matter if you use cheap American cheese or sophisticated Gruyère. For optimal results, sprinkle cheese on the inside and outside of the bread and cook the sandwich in a nonstick (or well-buttered) pan over medium-low heat. You'll be in caramelized-cheesy-heaven in no time.

| YOU ARE DOING A FREAKING GREAT JOB.

INVITE LUCK INTO YOUR LIFE

If horseshoes and rabbits' feet aren't doing the trick, try one of these good luck charms from around the globe.

- Three-legged frog statue (China)

- Chimney sweep (Europe)

- Money cat (Japan)

- Key (Italy)

- Egg (Ukraine)

- Hamsa (Israel)

- Daruma doll (Japan)

Fortune

FAVORS

the brave

—Terence

| YOU ARE DOING A FREAKING GREAT JOB.

The Way to Know Life is to Love many things.

| YOU ARE DOING A FREAKING GREAT JOB.

LITTLE *by* LITTLE
ONE TRAVELS FAR.

| YOU ARE DOING A FREAKING GREAT JOB.

HOLD fast TO WHAT IS good

| YOU ARE DOING A FREAKING GREAT JOB.

THE SUN SHINES not on us but IN US

—JOHN MUIR

A SIMPLE WORKSPACE MAKEOVER

The ancient Chinese art of feng shui can bring simplicity and positivity to any space you inhabit regularly. Practitioners believe that every object in a person's environment contributes to the state of his or her livelihood and affects the flow of energy ("chi") within the space.

Here are a few tips to beckon better vibes:

- To attract prosperity, place a plant in the back left corner of your desk, which is the space said to represent wealth.

- Place a reference book or inspiring intellectual object on the front left corner of your desk to invite wisdom into your work life.

- Add something made of wood for a boost of inspiration (this is especially effective if the object is placed in the eastern corner).

KISS

KEEP IT SIMPLE SELF

| YOU ARE DOING A FREAKING GREAT JOB.

BE YOUR OWN HERO

| YOU ARE DOING A FREAKING GREAT JOB.

STORMS MAKE TREES TAKE DEEPER ROOTS

DOLLY PARTON

ONE-BOWL VANILLA CUPCAKES

1 egg white
2 tablespoons sugar
1 teaspoon pure vanilla extract
2 tablespoons unsalted butter, melted
¼ cup all-purpose flour
¼ teaspoon baking powder
Pinch of salt
1½ tablespoons milk

1. Preheat the oven to 350°F. Line two muffin cups
 with paper or foil liners.

2. Whisk together the egg white and sugar in a large bowl.

3. Add the vanilla and melted butter and stir until
 combined. Add the flour, baking powder, and salt and
 stir until smooth. Stir in the milk.

4. Divide the batter equally between the two liners.

5. Bake the cupcakes until set, 10 to 12 minutes. Let cool
 completely, then frost as desired.

Makes 2 cupcakes

| YOU ARE DOING A FREAKING GREAT JOB.

SOMETHING Beautiful IS on the HORIZON.

| YOU ARE DOING A FREAKING GREAT JOB.

HAPPY-MAKING MUSIC

"Happy," Pharrell

"Sun Is Shining," Bob Marley

"A Place in the Sun," Stevie Wonder

"Sunny Afternoon," The Kinks

"Shiny Happy People," R.E.M.

"The Warmth of the Sun," The Beach Boys

"If It Makes You Happy," Sheryl Crow

"Walking on Sunshine," Katrina and the Waves

"You Are My Sunshine," The Pine Ridge Boys

"Don't Worry, Be Happy," Bobby McFerrin

"Good Day Sunshine," The Beatles

"If You Want to Sing Out, Sing Out," Cat Stevens

"Keep on the Sunny Side," The Carter Family

MEMOIRS THAT ASTONISH AND INSPIRE

I Know Why the Caged Bird Sings by Maya Angelou

The Woman Warrior by Maxine Hong Kingston

Angela's Ashes by Frank McCourt

The Year of Magical Thinking by Joan Didion

The Diving-Bell and the Butterfly by Jean-Dominique Bauby

Eat, Pray, Love by Elizabeth Gilbert

Tuesdays with Morrie by Mitch Albom

Long Walk to Freedom by Nelson Mandela

| YOU ARE DOING A FREAKING GREAT JOB.

| YOU ARE DOING A FREAKING GREAT JOB.

| YOU ARE DOING A FREAKING GREAT JOB.

WHAT YOU DO TODAY CAN IMPROVE ALL YOUR TOMORROWS

· RALPH MARSTON ·

| YOU ARE DOING A FREAKING GREAT JOB.

A Smooth Sea NEVER MADE A SKILLFUL SAILOR

YOU ARE DOING A FREAKING GREAT JOB.

enthusiasm IS THE MOST *important* THING IN LIFE

TENNESSEE WILLIAMS

YOU'RE A STAR

When Joni Mitchell sang "We are stardust . . ."
she was absolutely right. Every atom on Earth,
aside from hydrogen and the lightest elements,
was formed at the heart of a massive star
billions of years ago.

we are made of

STAR
STUFF

— Carl Sagan

| YOU ARE DOING A FREAKING GREAT JOB.

positive ANYTHING IS BETTER than NEGATIVE *nothing*

ELBERT HUBBARD

| YOU ARE DOING A FREAKING GREAT JOB.

YOU Look NICE TODAY

IT'S THE LITTLE THINGS

Regularly writing in a diary or on a blog can do wonders to relieve stress and boost your creativity. Try an "awesomeness journal" by jotting down a couple of the brightest moments from your day.

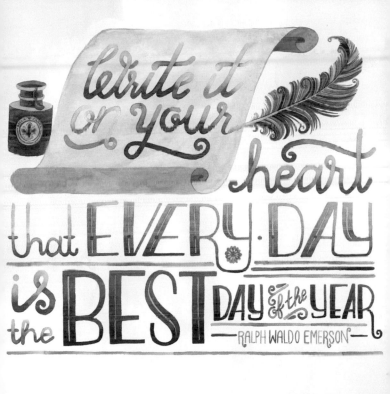

Write it on your heart that every day is the best day of the year.

—Ralph Waldo Emerson—

| YOU ARE DOING A FREAKING GREAT JOB.

| YOU ARE DOING A FREAKING GREAT JOB.

It is
astonishing
how short a time
it takes for very
wonderful
things
to happen.

Frances Hodgson Burnett

| YOU ARE DOING A FREAKING GREAT JOB.

WORSE & HAS

HAPPENED AT SEA

| YOU ARE DOING A FREAKING GREAT JOB.

WhatEVER you are be a good ONE

ABRAHAM LINCOLN

JOIN THE DREAM TEAM

You can make the most of your dreams through "lucid dreaming"—the ability to realize you are dreaming—and shape and explore the elements of the dream. Once lucid, you can fulfill fantasies (try flying or breathing underwater!) and investigate your subconscious.

| YOU ARE DOING A FREAKING GREAT JOB.

| YOU ARE DOING A FREAKING GREAT JOB.

NONE but ourselves CAN FREE OUR MINDS

BOB MARLEY

| YOU ARE DOING A FREAKING GREAT JOB.

You'll never find rainbows if you're looking down.

— Charlie Chaplin

THE ART OF BRAINSTORMING

There's no better feeling than when a lightbulb goes on, the gears shift into place, and something clicks in your mind. Austin Kleon, author of *Steal Like an Artist* and *Show Your Work*, describes the best way to get the ideas rolling: "Creative people need time to just sit around and do nothing. If you're out of ideas, wash the dishes. Take a really long walk . . . Take time to mess around. Get lost. Wander. You never know where it's going to lead you."

make IDEAS that create MORE IDEAS

| YOU ARE DOING A FREAKING GREAT JOB.

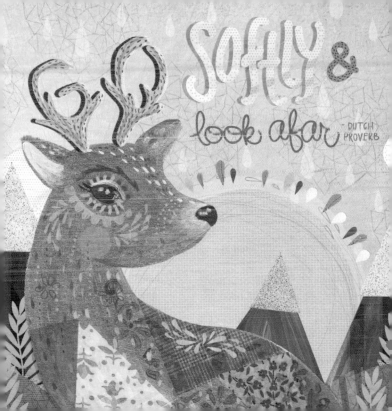

Go softly &
look afar
— DUTCH PROVERB

| YOU ARE DOING A FREAKING GREAT JOB.

| YOU ARE DOING A FREAKING GREAT JOB.

breathe deeply & repeat

| YOU ARE DOING A FREAKING GREAT JOB.

BEHOLD THIS DAY, IT IS YOURS TO MAKE.

BLACK ELK

| YOU ARE DOING A FREAKING GREAT JOB.

| YOU ARE DOING A FREAKING GREAT JOB.

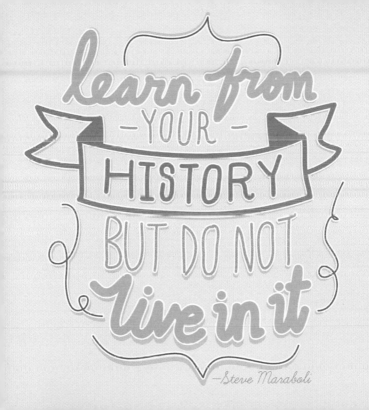

learn from
— YOUR —
HISTORY
BUT DO NOT
live in it

—Steve Maraboli

| YOU ARE DOING A FREAKING GREAT JOB.

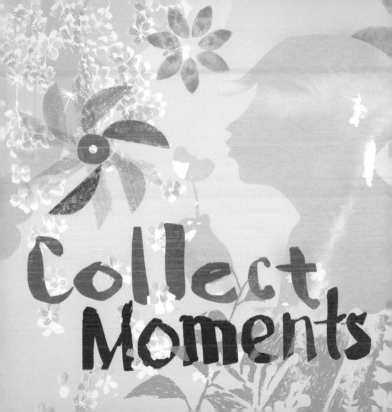

FAMOUS GAP-TOOTHED SMILES

Brigitte Bardot

Michael Strahan

Uzo Aduba

Madonna

Elton John

Anna Paquin

Samuel Jackson

David Letterman

Jessica Paré

Mike Tyson

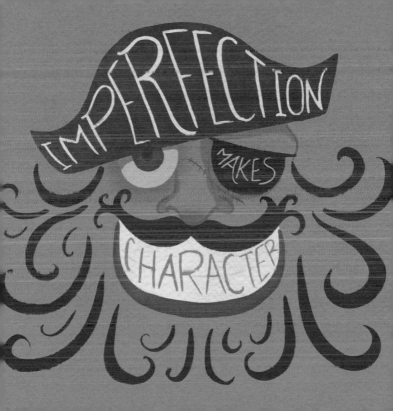

| YOU ARE DOING A FREAKING GREAT JOB.

I don't know where I'm GOING but I'm on my WAY

carl sandburg

YOU ARE DOING A FREAKING GREAT JOB.

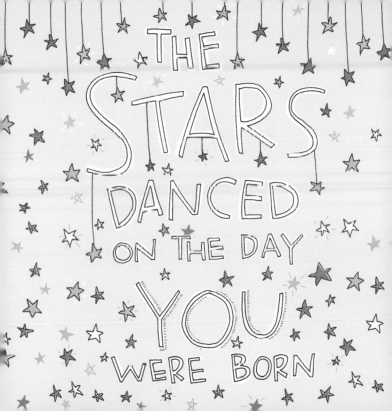

| YOU ARE DOING A FREAKING GREAT JOB.

Let it go

| YOU ARE DOING A FREAKING GREAT JOB.

| YOU ARE DOING A FREAKING GREAT JOB.

don't be afraid

TO GIVE UP

THE GOOD

TO GO FOR

THE GREAT

— JOHN D. ROCKEFELLER

| YOU ARE DOING A FREAKING GREAT JOB.

NOT YOUR AVERAGE OCEAN CRUISE

In 2010, artist and mariner Reid Stowe completed the longest sea voyage in history after 1,152 days of meandering the world's oceans on his homemade schooner. The 55-year-old meditated regularly and practiced yoga while subsisting on rainwater, fish, and sprouts he grew onboard.

TO REACH
PORT
WE MUST SET SAIL

—FRANKLIN D. ROOSEVELT

| YOU ARE DOING A FREAKING GREAT JOB.

Everything will be all right in the end. If it's not all right, then it's not yet the end.

Paulo Coelho

EASY AROMATHERAPY

Fill a ramekin with your favorite coffee beans
and place a tea light in the middle. The warmth
from the candle will draw out the scent of
the beans and fill your home with their rich,
inviting fragrance.

make SOMETHING Great !

| YOU ARE DOING A FREAKING GREAT JOB.

YOU are ALWAYS ENOUGH

| YOU ARE DOING A FREAKING GREAT JOB.

Nice Day to Start Again

| YOU ARE DOING A FREAKING GREAT JOB.

HAPPINESS COMES IN TINY PACKAGES

Here's just a handful of cheerful little
things to consider:

- Buttercups

- Teacup pigs

- Gummi bears

- Baby hedgehogs

- Dollhouse furniture

- Champagne grapes

- Petits fours

- Fun-size candy bars

- Babies' feet

- Pinky rings

enjoy the little things

| YOU ARE DOING A FREAKING GREAT JOB.

Creativity is Intelligence having Fun!

| YOU ARE DOING A FREAKING GREAT JOB.

A MASTER OF PATIENCE IS A MASTER OF EVERYTHING

—GEORGE SAVILE

| YOU ARE DOING A FREAKING GREAT JOB.

TO A GREAT mind, NOTHING IS little

SHERLOCK HOLMES

YOU ARE DOING A FREAKING GREAT JOB.

| YOU ARE DOING A FREAKING GREAT JOB.

Live
·IN THE·
moment

| YOU ARE DOING A FREAKING GREAT JOB.

BE IN LOVE WITH YOUR LIFE EVERY MINUTE OF IT.

~ JACK KEROUAC ~

IMAGE CREDITS

SOURCE LIST